T0113699

I DON'T NEED NO ROCKING CHAIR

JUST YET

K.B. CHANDRA RAJ

Order this book online at www.trafford.com
or email orders@trafford.com

Most Trafford titles are also available at major online book retailers.

Print information available on the last page.

ISBN: 978-1-6987-1279-6 (sc)
ISBN: 978-1-6987-1281-9 (hc)
ISBN: 978-1-6987-1280-2 (e)

Library of Congress Control Number: 2022918246

Trafford rev. 10/12/2022

 www.trafford.com
North America & international
toll-free: 844-688-6899 (USA & Canada)
fax: 812 355 4082

Contents

This book is dedicated to: THE PUBLIC LIBRARY

From the cosey comfort of an arm chair, cool in sultry summers, toasty and snug during frosty winters, at the public libraries in Colombo (Sri Lanka), Shelton and Hamden (U.S.A.) I have wet my feet in the holy waters of the Ganges, witnessed Moses crossing the Red Sea, listened to Marc Antony's oratorical bombast, "Friends, Romans, countrymen lend me your ears," watched Saint Teresa work her heart out in the slums of Calcutta, accompanied Edmund Hilary and Tensing Norgay on their ascent of Mount Everest and much more too numerous to enumerate.

In all my peregrinations across continents whenever I saw the words Public Library plastered on a building, like a duck to water I was attracted to it. A safe place where I was certain to read, relax, and ruminate.

All this with a plastic card given to me at no charge.

All the public library requested of me was just this: while you are in the library keep your mind open and your mouth shut.

My Salaams to Doug Hawthorne

Once more unto the breach pal, once more.

Thank you for readily undertaking once again the prosy tedious task of editing my work.

It has come out of the wash clean and meaningful.

Introduction

I was young once, confident, participated actively in sports -- cricket, soccer, badminton, table tennis – I carried away prizes. By my own measure, successful.

I am now 87 tremulously looking forward to 88 and beyond, what I would describe as the waning days of my life. Growing old means seeing our place on earth shrink bit by bit and watching our shadows begin to shrivel. It means in the end we will vanish completely. With age comes a growing thoughtfulness: what was it all for? What have we made of our lives, and how do we come to terms with our going?

As in the case of Tolstoy's classic, "The Death of Ivan Ilyich," toward the end of Ilyich's life, ambition and vanity disappear and priorities change. Like Ivan Ilyich I too look forward to comfort and companionship.

Learning new things or remembering familiar words have become daunting. The things I used to do with ease now require effort and it is by no means getting better. I walk more slowly than I used to. I have to be more attentive to where I'm putting my feet lest a momentary imbalance pitch me into a fall. How many times a day

I stand in a room slowly scanning the furniture for a clue about why I am there? My equanimity is lost when my password is denied again and again. As they say, "Everything goes south." Energy, reaction time, muscle tone, the body itself – they're all headed into the earth, as far south as it goes. The change from then to now is tectonic. In other words, I am aging. I have reached a chronological milestone.

Aging – a multidimensional process of psychological, mental, and social changes that have occurred over the course of a lifetime.

Rich man, Poor man, Beggar man, Thief, Saint, all will go through the aging process.

Old age is often described in such dismal terms that we could almost feel ashamed of growing old – to such an extent, indeed, that we might feel that we have to do everything we can in order to make it look as though we are not advancing in years.

Aging is dying slowly. Some die early, others take longer. Abkhazians, living in the Caucasus Mountains, have a reputation of living long and healthy lives. Claims have been made for a life span of 150 years and marriages at 110. Even they die, eventually. Methuselah, the Grand

Old Patriarch of the Old Testament, did eventually die, albeit at the age of 969.

There are those who never grow old because they are taken too soon. There are those who grow old without worries, enjoying everything life has to offer. There are those who desperately try to slow down the ticking clock.

As for me I don't want to grow old because I don't want to. I don't want to have diabetes I don't want to have pain in my body every single second of the day. I wish I could be young for ever so I don't get arthritis. As I have written:

> Young I was (true) but now am old
> Not yet
> Aching, shaking, creaking old
> I can walk and I can talk
> I can see and I can hear
> From afar or near
> Thank God
> I can read and I can write
> Like a bee's sting or a mosquito's bite
> Who can ask for more.

When we're young, death and those approaching it seem to have little to do with us. Old people don't look or act like us – they might almost be a different species. As for

death, we don't want it, of course, but why worry about it? It seldom happens to young people. We can freely do dangerous things.

When you think about it, our time of aging is perhaps the first time in our life when we have an unknown termination point. We know when we'll start school, when we'll get out of college, when we'll start our new job, when we are getting married, when we're going to retire.

I am fully aware every hour I'm closer to death than I was the hour before. I stand perpetually on the brink of the rest of my life. All of us draw closer to the end all the time, but rarely with the acute awareness that comes when old age or calamity reminds us of where we stand. I've watched one who was dearly loved die at peace. As to when we are going to die, we have no exact knowledge. Ay! there's the rub.

What you are about to read are my **musings** on aging. Call it my sticky journey from Diapers to Diapers. It offers no cure to aging. The book is not a "guide to" or handbook for getting old. I am cognizant of the fact "aged" is a broad category. It includes people who are very active and healthy, those with some limitations and those confined to bed or who are homebound.

Our society favors the young and devalues older people. In first encounters age is one of the earliest characteristics we notice about other people. Conscious or not, noticing age drives our interactions with others. How should I address them? What are their political views? How slowly should I talk? How loudly?

Many people approach age with dread. Today in America, we no longer see our elders as sources of wisdom but as feeble yet lovable doddering dears. The days of wise old Solomon are long gone.

Once Julius Caesar took control of the Roman empire Cicero, the famous Roman orator and statesman, could not support him. Rather than sinking into his wine cups or committing suicide as his friend the younger Cato had done, Cicero turned to writing. Cicero addressed the subject of old age in a short treatise entitled De Senectute.

Cicero, as far back as 45 BC while in his sixties and in a time when life span was short, was of the opinion the qualities that make the later years of our lives productive and happy should be cultivated from the beginning. The excesses of youth are more often to blame for the loss of bodily strength than old age. A wanton and wasteful youth yields to old age a worn-out body. Moderation,

wisdom, clear thinking, enjoying all that life has to offer-
-these habits we should learn while we are young because
they will sustain us as we grow older. The senior years,
he believed, can be very enjoyable if we have developed
the proper internal resources.

Mr. Cicero was out of touch with reality, I think. Fancy
calling our grandchildren, yours and mine, in their teens
and telling them, "Children, I want to tell you how you
should conduct yourselves from now on so when you get
to be old like me you will be happy." It does not work
that way.

Greek authors before Cicero wrote about the last phase
of life in different ways. Some idealized the elderly as
enlightened bearers of wisdom, while others caricatured
them as tiresome and constant complainers.

Poet Sapho from the sixth century BC is perhaps the most
striking of all ancient writers on the subject as she mourns
the loss of her youth in this fragmentary poem thus:

> My skin once soft is wrinkled now,
> My hair once black has turned to white.
> My heart has

become heavy, my knees that once danced nimbly like fawns cannot carry me. How often I lament these things
– but what can be done?

I wonder how she would have reacted if she had been told of Proverbs 16:31:

Gray hair is a crown of glory; it is gained in a righteousness life.

Each stage of life has its own appropriate qualities – weakness in childhood, boldness in youth, seriousness in middle age, and maturity in old age. What could be more ridiculous than for a traveler to add to his baggage at the end of a journey.

Grief, I have come to realize, is a natural and inevitable part of aging. It comes with the territory. If you get a lot of years, you get a lot of losses.

Why do people consider old age miserable?
It's because:
Takes us away from an active life.
Weakens the body.
Deprives us of almost all sensual pleasure.

It is not far from death even though no one
is so old that he doesn't think he will live
another year.

Consider these lines from a poem that Charles Lamb
wrote over 100 years ago:

I have been laughing, I have been carousing,
Drinking late sitting late with my bosom
cronies,
All, all are gone, the old familiar faces.

It's the laughter we will remember, whenever we recall
the way we were.

During the past six months it has been sad, indeed very sad.

Many of my friends, my contemporaries, some are very ill,
mostly old age-related illnesses, and many have passed away.

As a man ages, he looks back on his life. He remembers
all the love and fun he had. He remembers his youth. It
is with the progression of time that he dwells upon his
past and fears the worst to come. Leo Tolstoy said, "The
biggest surprise in a man's life is old age." How true!

As a man ages, he looks in the mirror and does not
recognize himself. He looks for wrinkles, crow's feet, and
gray hair.

When I shave, I'm forced to look into the
mirror,
And every time I think to myself,
(Not "what a wonderful world")
That's not me, Man! it just cannot be true,
How come my heart is young; only time
just flew,
I keep staring at this old, funny face,
And I swear: For sure it's someone else in
my place.

The elderly man, who is none other than me of course,
notices that his skin does not retain the elasticity that it
used to. He also notices the body parts are not firm or
in place as they used to be. They sag with the passing of
time.

He wonders what happened to his youth. Where has his
youth gone? And he thinks he may never be handsome or
beautiful again.

It is scary for one to see a loved one, who had good
hearing and was physically active one year, has the next
lost his hearing, is denying himself food, and is not as
alert as he used to be. He cannot remember what day
of the week it is, the names of his children and other
family members. It evokes pity and sadness to see an aged

person close to death revert back to the infantile stage when he needed to be held, cared for, and never to be left alone. He craves for his independence not realizing his independence left him long ago.

While we have to face death as being inevitable, an aged person looks back on his past experience and wonders where his youth has gone and whether his time was well spent. A young person generally does not appreciate what he currently has.

The plight of the elderly is often overlooked.

Aging is a fact of nature. Everything ages and eventually dies. For people living today this is often a source of fear and anxiety because death, as Shakespeare points out, is "the undiscovered country from whose bourn no traveler returns."

Old age is something nobody warns you about. Even if they did, you would pay little heed.

I recall.

It was in a tiny island in the Indian Ocean that I grew up. I would from the high school dormitory during vacation visit my grandmother. She would complain that she has

aches and pains and is very forgetful. I paid no attention. Old age is for other people or so I believed.

Old age is like some frightening monster you try to run away from, but you find your shoes are heavy. So, your every move is suddenly in slow motion.

And yet it must be said there are those who are quite sure of themselves. Not many I dare say.

Here's Walter Savage Landor on his seventy-fifth birthday:

> "I strove with none, for none was worth
> my strife;
> Nature, I loved, and, next to Nature, Art;
> I warmed both hands before the fire of life;
> It stinks, and I am ready to depart."
> Or William Henley's cocksure confidence:
> "It matters not how strait the gate,
> How charged with punishments the scroll,
> I am the master of my fate,
> I am the captain of my soul."

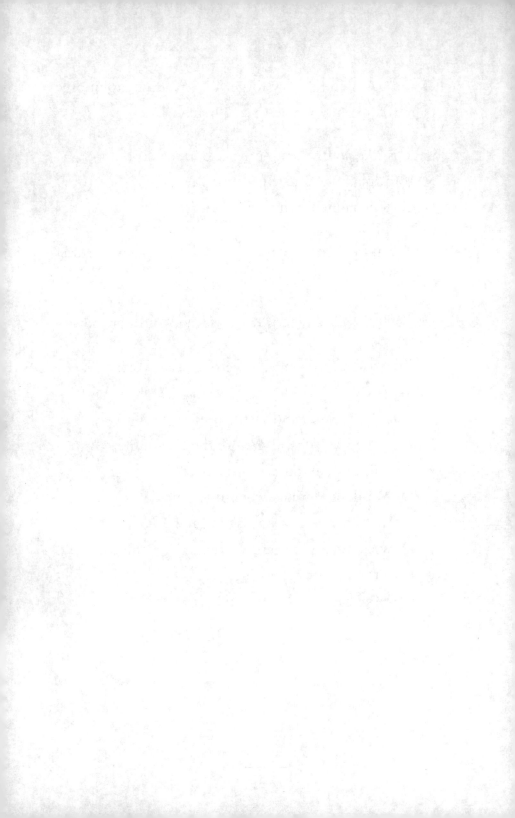

Poetry

Why did I choose the medium of poetry? The power of the word moves us, above all the power of poetry. Poetry can help to give us a fresh language to think about aging and these poems are chosen to fortify, celebrate, lament, grieve, rage and ridicule. These poems may not console, but they can widen our perspectives, helping us to change our attitudes. The poems I offer in this book are, of course, only a small collection of the many poems speaking to aspects of aging.

Who better to write upon the subject of aging than those who have experienced it and who have a special gift with words in order to relate those experiences? Poems by renowned poets make us aware of the hard times ahead.

Poetry has redemptive power for me, as it does for millions of people. Poets like Milton and Marlow have provided life jackets to keep me afloat, ballast to keep me from ascending to altitudes where there's not enough oxygen to support life, maps to keep me from getting lost in the wilderness. Great poets like Shakespeare, Dickens and Donne have a way of sneaking up on me to deliver lasting messages.

Shortly after the Titanic sank in April 15, 1912, it is reported in the <u>New York Times</u> that readers began sending the <u>Times</u> poems about the tragedy. People have always dealt with memorable events by writing poems. Poems inject pleasure which is immediate. If words have rhyme and meter, its poetry.

Just reading the right words put into the right order on a sheet of paper can produce tears in someone who never met the person who wrote those words and who lives many centuries after the poet. I believe poetry offers us a fresh language which can help us recognize, tackle, and ultimately embrace our aging. Most of the time it is subjective.

Poets were obsessed, nay fixated, by the swift passage of time.

Poetry itself is not immune from the aging process. Romanticism gave way to 20th century modernism.

Poems can be expressed effectively and in endearing lines.

A couple of examples:

"To His Coy Mistress," by Andrew Marvell:

The lover pleads in colloquial parlance, "hurry up."

"Had we but World enough and Time, this
coyness, Lady, were no crime.
We would sit down, and think which way
to walk, and pass our long love's day.

…..

But at my back I always hear
Time's winged chariot hurrying near. . . ."

And R.L. Stevenson cautions:

"Gather ye roses while ye may
Old Time is still a – flying

. . . .

The very flowers you pluck to-day
Tomorrow will be dying,
And all the flowers are crying,
And all the leaves have tongues to say,
Gather ye roses while ye may."

As one author puts it: "A poem, too, is a blossoming in
words of a language at a certain time in its history, and
words stand for things, objects, actions, as well as ideas.

It is often the work of one man living in a certain place
and period and setting and state in a bye-gone century.

We can skip from rhyme to rhyme, dream on from poem
to poem, and ignore everything else.

The cock crows at midnight; and for miles and miles around his kinsmen answer. The fowler whistles his decoy for the wild duck to come. Rhymes and poems affect our minds and will continue to do so."

Consider these lines:

"He was my North, my South, my East and West,
My working week and my Sunday rest,
My noon, my midnight, my talk, my song;
I thought that love would last forever: I was wrong."

"The stars are not wanted now: put out every one;
Pack up the moon and dismantle the sun;
Pour away the ocean and sweep up the wood;
For nothing now can ever come to any good."
(from "Funeral Blues" by W. H. Auden)

"Poets are the unacknowledged legislators of the world" – Shelley.

Poetry is the expression of the imagination and one's intimate experience. Poetry is connate with the origin of man.

Poetry is superior to prose, even though both use language, because poetry also taps into the possibilities of sound.

Poems are more often heard than read.

Here's what I mean:

"The Raven" by Edgar Allan Poe:

> Once upon a midnight dreary, while I
> pondered weak and weary,
> Over many a quaint and curious volume of
> forgotten lore,
> While I nodded, nearly napping, **suddenly
> there came a tapping,**
> As of someone gently **rapping, rapping** at
> my chamber door.
> "'Tis some visitor," I muttered, "**tapping** at
> my chamber door—
> Only this and nothing more."

Poetry offers us a fresh language which can help us recognize, tackle and ultimately embrace our aging.

I enjoy reading poems for they are short (most of them anyway) and give it to us all in a single booster shot. I plead to writers of epic poems like the Mahabharata: Write half a word, please, if you can, for I have a very short *attention* span.

This is why I have chosen the language of poems to address the subject of *Aging*.

I often think of what we call the "good old days" and am saddened that they are gone forever and so have many of my dear friends.

Charles Lamb expresses this feeling of nostalgia with telling effect in the poem, "The Old Familiar Faces," a few lines of which I quoted above. The poem ends in this way:

> How some they have died, and some they
> have left me,
> And some are taken from me; all are
> departed;
> All, all are gone, the old familiar faces.

With all the enthusiasm I can summon I echo the words of Derek Walcott in "Sea Canes,"

> "Half my friends are dead. I will make you
> new ones, said earth.
> No, give me them back, as they were
> instead, with faults and all I cried."

Gulliver's Travels writer Jonathan Swift wrote "that all people would like to live long, but no one would want to grow old," even though aging is a natural process unavoidable and inseparable from end-of-life. We are all,

as one writer puts it, "dust of the past and seed of the future."

The process of aging begins at birth and continues throughout life. This is a fact, an unsolicited, inescapable, irreversible certainty.

Somethings we cannot accept as our bodies lose themselves, one organ at a time. That sad stripping away process.

We are often embarrassed by the pejoratives associated with aging, the language especially: "Old-fogey," "Fossil," "Fuddy duddy," "back number," and so on.

These pejoratives are sweetened (whom are you kidding?) by calling the same Fossils "Venerable," "Seniors," "Experienced," and so on.

I thought about aging of not just humans but of all organic matter; the trees, the plants and the animals and how towering civilizations such as the Indus Valley, Persian, Maya and Greek, all aged and died, how landscapes both rural and urban age, and how our planet itself is aging, dying.

Shelley in "Ozymandias" shows us the fleetingness of all things human. Eventually they all must perish.

"I met a traveler from an antique land,
Who said:
'Two vast and trunkless legs of stone
Stand in the desert. . .. Near them, on the sand,
Half sunk a shattered visage lies, whose frown,
And wrinkled lip, and sneer of cold command,
Tell that its sculptor well those passions read which yet
survive, stamped on these lifeless things,
The hand that rocked them, and the heart that fed;
And on the pedestal, these words appear:
My name is Ozymandias, King of Kings;
Look on my Works, ye Mighty, and despair!
Nothing beside remains. Round the decay
of that colossal wreck, boundless and bare
the lone and level sands stretch far away.'"

If that is not convincing enough, I give this.

Eighteenth century poet Thomas Gray wrote this mournful poem titled "Elegy Written in a Country Graveyard" in a country church burial ground:

"The boast of heraldry, the pomp of power,
And all that wealth e'er gave.
Awaits alike the inevitable hour,
The paths of glory lead but to the grave."

Such quatrains are a continuous reminder of the mortality of human life and the inevitability of death irrespective of social position, beauty, wealth or any glory. Ironically and perhaps fittingly, it was the same burial site where Thomas Gray was later buried.

Maya Anjelou writes in "Even the Stars Look Lonesome" how it is when we are by ourselves and silent that we are able to converse with ourselves, ask questions, and get to know ourselves. She even says we may "hear the voice of God."

Growing old is the most solitary of journeys. There is nothing older than not wanting to grow old. The old: we make them feel like excess baggage.

A Chinese story gives this context:

"It tells of an old man who's too weak to work in the garden or help with household chores. He just sits on the porch, gazing out across the fields while his son tills the soil and pulls up the weeds. One day the son looks up at the old man and thinks, 'What good is he now that he's so old. All he does is eat up the food! I have a wife and children to think about. It's time for him to be done with life!' So, he makes a large wooden box, places it on a wheelbarrow, rolls it up to the porch, and says to the old man, 'Father, get in.'

The father lies down in the box and the son puts the cover on, then wheels it off toward the cliff. At the edge of the cliff, the son hears a knock from inside the box.

'Yes, Father?' the son asks. The father replies, 'Why don't you just throw me off the cliff and save the box? Your children are going to need it one day.'" (From the book <u>Still Here</u> by Ram Dass)

In the Middle Ages in certain regions of Japan, it was the custom for elderly people to go and die alone in the forest in order to spare the young the cost of having extra mouths to feed.

In Canada in the days before the government instituted social- protection laws for the Inuit, the oldest would go off alone and die in the fields. (From <u>The Art of Growing Old - Aging with Grace</u> by Marie de Hennezel)

There is nothing older than not wanting to grow old.

Providentially I stumbled upon two poems which made me think seriously about aging.

1. Maya Angelou on Aging:

Maya Angelou like Shakespeare, Charles Dickens, Mark Twain, H.G.Wells, George Bernard Shaw and many more never studied at a university.

Maya Angelou, a woman with no more than a high school education, was appointed Reynolds Professor at Wake Forest University in Winston- Salem, North Carolina.

She has written five volumes of autobiography, including the best- selling <u>I Know Why the Caged Bird Sings</u> and many collections of poetry.

Maya Angelou did not publish her first book of poetry until she was in her 40s.

Tragically, when she was eight years old, Maya was raped by her mother's boyfriend. For five years thereafter she did not speak.

At the age of 16, Maya Angelou became pregnant. At the age of 24, she married a Greek sailor, Tosh Angelous, and took a version of his name.

In her book of essays entitled "<u>Even the Stars Look Lonesome</u>," she writes about how the ailments accompanying old age do not depress her. In fact, she finds advantages: she laughs more, forgives more quickly, and is delighted to both receive and give gifts.

Poetry grew naturally from Angelou's work in theater and songwriting. Her poems often feature song-like

repetitions of lines and verses as well as the rhythm of spoken language, simple word choices, including slang and the charm of double negatives like "Don't Bring Me No Rocking Chair."

Shakespeare resorted to double negatives for effect.

In the Merchant of Venice, Salerno says, "Not in Love Neither."

And Mick Jagger sings, "I can't get no satisfaction."

"On Aging" by Maya Angelou

I was moved. The rhythm, the rhyme, the subtle humor, the plaintive undertone got to me. And so, the title of this book:

"I Don't Need No Rocking Chair," a variation on Angelou's "Don't Bring Me No Rocking Chair." As Angelou says, she is "the same person I was back then"

We must remember every moment does not need to be stuffed. Silence is a fullness, not a vacuum. One advantage of age is to be able to learn the secrets of an empty room.

Doing nothing is not empty. Let the tide of silence close over your head.

2. The other poem that moved me is one circulating on social media, written by an unknown old man in a geriatric ward.

When an old man died in the geriatric ward of a home in an Australian country town, it was believed that he had nothing left of any value. (Fancy that – read on.)

Later, when the nurses were going through his meager possessions, they found this poem. Its quality and content so impressed the staff that copies were made and distributed to every nurse in the hospital.

One nurse took her copy to Melbourne. The old man's sole bequest to posterity has since appeared in the Christmas editions of magazines around the country and is appearing in magazines for mental health. A slide presentation has also been made based on his simple but eloquent poem.

And this what this unknown old man, with nothing left to give to the world, wrote many years ago:

What do you see nurses? What do you see?
What are you thinking when you are looking at me?
A cranky old man not very wise,
Uncertain of habit with faraway eyes?
Who dribbles his food and makes no reply;
When you say in a loud voice, "I do wish you'd try!"
Who seems not to notice the things that you do;
and forever is losing a sock or shoe?

Who resisting or not lets you do as you will,
With bathing and feeding the long day to fill.
Is that what you're thinking? Is that what you see?

Then open your eyes, nurse, you are not looking at me.
I'll tell you who I am as I sit here so still,
As I do at your bidding, as I eat at your will.

I'm a small child of ten with a father and mother,
brothers and sisters who love one another,
A boy of sixteen with wings on his feet dreaming that
soon now a lover he'll meet.
A groom soon at twenty my heart gives a leap.
Remembering the vows that I promised to keep.

At twenty-five now I have young of my own,
Who need me to guide and a secure happy home;
A man of thirty my young now grown fast,
Bound to each other with ties that should last.

At forty, my young sons have grown and are gone,
But my woman is beside me to see I don't mourn.

At fifty, once more babies play 'round my knee,
Again, we know children my loved one and me.
Dark days are upon me, my wife's now dead.
I look at the future I shudder with dread,
For my young are rearing young of their own.
And I think of the years and the love that I've known.

I'm now an old man and nature is cruel.
It's jest to make old age look like a fool.

The body, it crumbles, grace and vigor depart.

There is now a stone where I once had a heart.

But inside this old carcass a young man still dwells, And, now and again my battered heart swells,

I remember the joys, I remember the pain.

And I'm loving and living life over again.

I think of the years, all too few gone too fast

So, open your eyes people open and see.

Not a cranky old man,

Look closer …see…Me!!

Let's remember this when we next meet an older person who we might brush aside without looking at the young soul within.

We are all certain to be one day there too.

When I see young girls and boys on their blades, sun on their faces, wind in their hair racing in the park without a care, then I understand ageing.

When I find myself smiling at babies in their push carts and strollers; when I find myself smiling at strangers, I know I am old.

Age versus Youth

There is constant "hand-to-hand" combat between aging and wanting to remain young.

Maya Angelou in her book "Even the Stars Look Lonesome" fantasizes about how she would become more practical in her clothing as she gets older but remain elegant, still accompanied by handsome men.

Then reality descends upon her like a thunderbolt. Just as Robert Burns wrote about best laid plans, Maya Angelou finds that hers (like mine) went awfully a-gley. Her body turns on her and begins to show the typical signs of aging such as wrinkles, some extra weight, and saggy skin. Robert Burns was right about 'The best laid schemes' Mine certainly went awfully 'a-gley.'"

The obsession to retain youth and dodge old age we see repeatedly in poetry and novels. Literature is ripe with tales of aging.

In the book <u>The Picture of Dorian Gray</u> by Oscar Wilde, the story revolves around a portrait of Dorian Gray by Basil Howard, an artist impressed and infatuated by Dorian's beauty. Through Basil, Dorian meets Lord

Henry Wotton and is soon enthralled by the aristocrat's hedonistic world view. Dorian expresses the desire to sell his soul to ensure that the picture rather than he will age. The wish is granted. Dorian pursues a libertine life while staying young and beautiful, all the while, the portrait ages and records every one of Dorian's sins.

Alfred, Lord Tennyson approached the topic with irony, basing his poem "Tithonus" on the plight of the Greek mortal who was granted immortality by Zeus thanks to his lover, the goddess Eos. Eos, the dawn of the day, was the sister of the Sun and Moon and the mother of the four winds. Arriving ahead of her brother, the Sun, she woke the Earth each day with the morn's soft glow. Like her sister, the Moon, she was also inclined to find love among the mortals. Early one morning as she gazed upon the Earth, she saw Tithonus, a prince of Troy. Enthralled by his beauty, she resolved to make him her husband. There was however, a problem. For an immortal, the whole of a human life is but a brief interlude. Propelled by her desire, Eos went to Zeus and asked him to grant Tithonus eternal life. He turned her away, telling her that it was not right that a man should live forever. Relentless, Eos pleaded until Zeus agreed.

Newly immortal, Tithonus joined Eos in her magnificent palace in the East. Many happy years passed until Eos found to her horror that Tithonus was growing old.

Belatedly, she understood that in her haste to gain for Tithonus the gift of eternal life, she had forgotten to ask that her lover be granted eternal youth as well. When his hair turned white, she left his company but allowed him to remain in her palace. In time he lost the power to move his limbs and his voice faded into a faint chirp. Denied the release of death, Tithonus aged like no man ever had before. At last, Eos took pity on him and changed him into a grasshopper. When you hear a grasshopper chirping that's Eos.

Interestingly this is not the only age-related tale of love and loss the ancient Greeks had to offer.

Selene, the Moon, sailed the night sky while the Sun rested. One night her pale white light fell upon the handsome young shepherd Endymion. She fell instantly in love with him and determined to make him her own. Remembering the hard lesson learned by her sister, Eos, Selene was careful to ask Zeus to grant her lover eternal youth as well as eternal life. Once again, Zeus was reluctant to grant such a wish. Selene, who was as stubborn as her sister, pestered Zeus until he agreed to do as she wished. Endymion was made both immortal and forever young.

"Even when we are young, we glimpse it sometimes, and nod our heads when a grandfather dies," writes Donald

Hall in his poem "Affirmation." The *it* he refers to is, of course, age, and its attendant sense of mortality. Similarly, Julia Kasdorf, in her poem "First Gestures" alludes to the discovery, early in life, that all things will eventually disappear:

> "Among the first we learn is good-bye, your
> tiny wrist between Dad's fore-finger and
> thumb forced to wave bye bye to Mom."

Rare is the poet who lives to old age but does not write about it. Most view aging as a loss – of vigor, health, and love. Some poets yearn for their youth or pity their shriveling bodies.

Lear, suffering from dementia, wails, "Pray, do not mock me. I am a very foolish fond old man." Fond meaning idiotic, imbecilic, and dazed.

William Butler Yeats's "When You Are Old" depicts old age with regret:

> "When you are old and gray and full of sleep,
> And nodding by the fire, take down this book
> And slowly read, and dream of the soft look
> Your eyes had once, and of their shadows deep."

After considerable study and research, I have made a collection of verses by renowned poets dealing with the haunting, the withering, and the dreadful prospect of aging that awaits all of us.

The poets in this section need no introduction. They are well known. Who better to write upon the subject of aging than those who have experienced it and who have a special gift with words in order to relate those experiences?

My hope is that reading the poems will make aging, if not something to wish for, at least something to be anticipated. You should be forewarned that it is an experience that will visit you sooner or later . . . hopefully later.

1. Crossing the Bar

Alfred, Lord Tennyson

Sunset and evening star.
And one clear call for me!
And may there be no moaning of the bar,
When I put out to sea.

But such a tide as moving seems asleep,
Too full for sound and foam,
When that which drew from out the boundless deep
Turns again home.

Twilight and evening bell,
And after that the dark!
And may there be sadness of farewell.
When I embark;

For though from out our borne of Time and Place
The flood may bear me far,
I hope to see my Pilot face to face when
I have crost the bar.

2. What goes faster every time I turn around

Anonymous

How odd as I age, I move slower.
And time runs twice as fast.

. . . .

Death belonged to the other
people. Every promise was
forever and several days.

Now time runs through the
sieve of my vanished hands

3. To the Virgins, to Make Much of Time

Robert Herrick

Gather ye rosebuds while ye may,
Old Time is still a-flying;
And this same flower that smiles today
Tomorrow will be dying.

The glorious lamp of heaven, the sun,
The higher he's a-getting,
The sooner will his race be run

And nearer he's to setting.

That age is best which is the first,
When youth and blood are warmer;

But being spent, the worse, and worst
Times still succeed the former.

Then be not coy, but use your time,
And while ye may, go marry;

For having lost but once your prime,
You may forever tarry.

4. On A Fly Drinking Out of His Cup

William Oldys

Busy, curious, thirsty fly!
Drink with me and drink as I:
Freely welcome to my cup,
Couldst thou sip and sip it up:
Make the most of life you may,
Life is short and wears away.
Both alike are mine and thine
Hastening quick to their decline:
Thine's a summer, mine's no more,
Though repeated threescore.
Threescore summers, when they're gone,
Will appear as short as one!

5. Macbeth (Act 5, Scene 5)

William Shakespeare

"Tomorrow, Tomorrow, and Tomorrow,
Creeps in this petty pace from day to day,
To the last syllable of recorded time;
And all our yesterdays have lighted fools
The way to dusty death."

[Macbeth speaks these lines as he has been informed of the death of his wife, Lady Macbeth.

The death prompts Macbeth to reflect upon the futility of all his extreme ambition which had spurred him on to commit murder and take the kingdom for himself. It has all been for nothing. He is now alone.

The speech is about the futility and illusoriness of all life and whatever we do, remembering we are all bound for the grave.]

6. Antony and Cleopatra (Act 2, Scene 2)

William Shakespeare

"Age cannot wither her, nor custom stale her infinite variety"

[These words are among the most well-known and oft-quoted from William Shakespeare's later tragedy, "Antony and Cleopatra," about the love affair between Mark Antony and the Queen of Egypt.

Enobarbus, a follower of Mark Antony, has just been describing the appearance of Cleopatra, Queen of Egypt as she rode her barge down the river Cydnus when Mark Antony first clapped his eyes on her and fell head over heels in love with her.]

7. For the Fallen

Laurance Binyon

[I recommend reading the passage from Antony and Cleopatra in conjunction with Laurance Binyon's poem, "For the Fallen." It's about age, the fear of getting old--the fear of withering like a plant and dying. Laurance Binyon's poem is more often heard than read since it is frequently recited as part of Remembrance Sunday Commemorations for those who fought and died in the First World War.]

They shall grow not old, as we that are left grow old:
Age shall not weary them, nor the years condemn.
At the going down of the sun and in the morning
We will remember them.

8. Let Me Grow Lovely

Karle Wilson Baker

Let me grow lovely, growing old,
So many fine things do:

. . . .

Like grandma's ivory and gold,
Skills and silks never grow old,
Old streets like fond memories for
me a glamour hold,
I'll such as these grow lovely growing old.
Behold!

9. Evening Pastimes

Alice Cary

Sitting by my fire alone,
When the winds are rough and cold,
And I feel myself grow old
Thinking of the summers flown.
I have many a harmless art
To beguile the tedious time:
Sometimes reading some old rhyme I
already know by heart.

10. Cymbeline (Act 4, Scene 2)

William Shakespeare

Fear no more the heat o' the sun,
Nor the furious winter's rages;
Thou thy worldly task hast done,
Home art gone, and taken thy wages:
Golden lads and girls all must,
As chimney-sweepers, come to dust.

Fear no more the frown o' the great;
Thou art past the tyrant's stroke;
Care no more to clothe and eat;
To thee the reed is as the oak: The
scepter, learning, physic, must All
follow this, and come to dust.

Fear no more the lightning flash,
Nor the all-dreaded thunder stone; Fear
not slander, censure rash;
Thou hast finished joy and moan: All
lovers young, all lovers must
Consign to thee, and come to dust.

No exorciser harm thee!
Nor no witchcraft charm thee!
Ghost unlaid forbear thee!
Nothing ill come near thee!
Quiet consummation have;
And renowned be thy grave!

[Every one dies. From the oligarchs and the beautiful lads and girls to the humble chimney sweepers all must eventually come to dust.]

11. Sonnet 66

William Shakespeare

Tired with all these, for restful death I cry:
As, to behold desert a beggar born,
And needy nothing trimmed in jollity,
And purest faith unhappily forsworn,
And gilded honor shamefully misplaced,
And maiden virtue rudely strumpeted,
And right perfection wrongfully disgraced,
And strength by limping sway disabled,
And art made tongue-tied by authority,
And folly, doctor-like, controlling skill,
And simple truth miscalled simplicity,
And captain good attending captain ill:
Tired with all these, from these would I be gone,
Save that, to die, I leave my love alone.

12. Nature

Henry Wadsworth Longfellow

As a fond mother, when the day is o'er,
Leads by the hand her little child to bed,
Half willing, half reluctant to be led,
And leave his broken playthings on the floor,
Still gazing at them through the open door,
Nor wholly reassured and comforted
By promises of others in their stead,
Which, though more splendid, may not please him more;
So, nature deals with us, and takes away
Our playthings one by one, and by the hand
Leads us to rest so gently, that we go
Scarce knowing if we wish to go or stay,
Being too full of sleep to understand
How far the unknown transcends the what we know.

[Nature is to man what a mother is to her child. As we advance in years, nature gradually takes away all our earthly possessions and at the same time dulls all our senses. The final goal of our life is the long rest in a world beyond the grave.

But so greatly attached are we to our earthly life that we are never too willing to proceed towards that goal. But nature leads us so gently to this final goal of life that we follow her almost in a trance.

We gradually proceed towards the final end of our life, not out of our own accord but because nature leads us gently, affectionately, and inevitably towards it.]

13. When I see the young men at play

Thomas Stanley

When I see the young men at play,
Young me thinks I am as they;
And my aged thoughts lay's by,
To the Dance, with Joy I fly;
Come, a flowery Chaplet lend me,
Youth, and mirthful thoughts attend me;
Age be gone, we'll dance among
Those that young are and be young:
Bring some Wine Boy, fill about;
You shall see the old Man's stout;
Who can laugh and tipple too,
And be mad as well as you.

14. Growing Old

Matthew Arnold

What is it to grow old? Is it to
lose the glory of the form, The
luster of the eye?
Is it for beauty to forego her wreath? —Yes,
but not this alone.
Is it to feel our strength—
Not our bloom only, but our strength—decay?
Is it to feel each limb
Grow stiffer, every function less exact, Each
nerve more loosely strung?
Yes, this, and more; but not
Ah, 'tis not what in youth we dreamed 'would be!
'Tis not to have our life
Mellowed and softened as with sunset glow, A
golden day's decline.
'Tis not to see the world
As from a height, with rapt prophetic eyes,
And heart profoundly stirred;
And weep, and feel the fullness of the past,
The years that are no more.

It is to spend long days
And not once feel that we were ever young;
It is to add, immured
In the hot prison of the present, month To
month with weary pain.
It is to suffer this,
And feel but half, and feebly, what we feel.
Deep in our hidden heart
Festers the dull remembrance of a change,
But no emotion—none.
It is—last stage of all—
When we are frozen up within, and quite
The phantom of ourselves,
To hear the world, applaud the hollow ghost
Which blamed the living man?

[The poem basically revolves around getting old and old age. The fundamental theme of the poem "Growing Old" is the issue of aging.

The poem is about the misfortune of old age, which is to forget what it was like to be young. Arnold says when someone gets old, he seems as though he is losing glories and fading away from his life and from the shines of youth.]

15. To His Coy Mistress

Andrew Marvell

Had we but world enough and time,
This coyness, lady, were no crime. We
would sit down, and think which way to
walk, and pass our long love's day.
Thou by the Indian Ganges' side
Should rubies find; I by the tide
Of Humber would complain.
I would love you ten years before the flood,
And you should, if you please, refuse till the conversion
of the Jews.
My vegetable love should grow
Vaster than empires and more slow;
A hundred years should go to praise
Thine eyes, and on thy forehead gaze;
Two hundred to adore each breast,
But thirty thousand to the rest;
An age at least to every part,
And the last age should show your heart.
For, lady you deserve this state,
Nor would I love at a lower rate.

But at my back I always hear
Time's winged chariot hurrying near;
And yonder all before us lie Deserts
of vast eternity.
And your quaint honor turns to dust,
And into ashes all my lust; The
grave's a fine and private place,
But none, I think, do there embrace.
Now therefore, while the youthful hue
Sits on thy skin like morning dew,
And while thy willing soul transpires
At every pore with instant fires,
Now let us sport us while we may,
And now, like amorous birds of prey,
Rather at once our time devour
Than languish in his slow-chapped power.
Let us roll all our strength and all
Our sweetness up in one ball,
And tear our pleasures with rough strife
Through the iron gates of life:
Thus, **though we cannot make our sun Stand
still, yet we will make him run.** At the going
down of the sun and in the morning
We will remember them.

16. Forgetting to Remember

K.B. Chandra Raj

My forgetting is getting better
But my remembering is totally broke
To you my friend that may seem very funny
But to me that is no blo..dy joke.

When I'm here I'm wondering
If I really should be there,
And, when I try to think it through,
I haven't got a prayer!

Oft times I walk into a room,
Say, "Man what am I here for?" I
wrack my brain, but all in vain
A zero is my score.

At times I put something very carefully away
Where it is safe, but O my O my
The person it is safest from I'm ashamed to say is
very often who else but me!

When grocery shopping at the super market
I see someone, very familiar, seen him many times before;
He says "Hi" to me. We have a hearty chat;
When the person walks away
"Who was that?" my wife asks me,
At the gym? At the library?
Search Me.

17. That's Not Me

K.B. Chandra Raj

When I shave
I'm forced to look into the mirror,
And every time I think to myself,
(Not "what a wonderful world")
That's not me; Man! it just cannot be true,
How come my heart is young; only time just flew,
I keep staring at this old, funny face, and I swear!
"For sure it's someone else in my place"

18. Long Ago

Eugene Field

I once knew all the birds that came
And nested in our orchard trees;
For every flower I had a name–
My friends were woodchucks, toads and bees
I knew where thrived in yonder glen
What plants would soothe a stone – bruised toe–
Oh, I was very learned then;
But that was very long ago!

I knew the spot upon the hill
Where checkerberries could be found,
I knew the rushes near the mill
Where pickerel lay that weighed a pound!
I knew the wood, - the very tree
Where lived the poaching, saucy crow,
And all the woods and crows knew me –
But that was very long ago.
And pining for the joys of youth,
I tread the old familiar spot
Only to learn this solemn truth:

I have forgotten, am forgot.
Yet here's this youngster at ray knee
Knows all the things I used to know;
To think I once was wise as he –
But that was very long ago.

I know it's folly to complain
Of whatsoever the Fates decree;
Yet were not wishes all in vain,
I tell you what my wish should be:
I'd wish to be a boy again,
Back with the friends I used to know;
For I was, oh! so happy then –
But that was very long ago!

19. Let Me But Live

Henry Van Dyke

Let me but live my life from year to year,
With forward face and unreluctant soul;

. . . .

So let the way wind up the hill or down, 'er
rough or smooth, the journey will be joy:
Still seeking what I sought when but a boy,
New friendship, high adventure, and a crown,
My heart will keep the courage of the quest,
And hope the road's last turn will be the best.

20. The Last Leaf

Oliver Wendell Holmes

[To quote the last few lines:]

And if I should live to be
The last leaf upon the tree
In the spring
Let them smile, as I do now,
At the old forsaken bough
Where I cling.

21. Growing Old

Margaret E. Sangster

Is it parting with the roundness
Of the smoothly molded cheek?
Is it losing from the dimples
Half the flashing joy they speak?
Is it fading of the luster
From the wavy, golden hair?
Is it finding on the forehead
Graven lines of thought and care?

Is it dropping, as the rose-leaves
Drop their sweetness overblown,
Household names that once were dearer,
More familiar than our own?
Is it meeting on the pathway
Faces strange and glances cold,
While the soul with moan and shiver Whispers
sadly, "Growing old "?

Is it frowning at the folly
Of the ardent hopes of youth?
Is it cynic melancholy

At the rarity of truth?
Is it disbelief in loving?
Selfish hate, or miser's greed?
Then such blight of Nature's noblest
Is a "growing old" indeed.

But the silver thread that shineth
Whitely in the thinning trees,
And the pallor where the bloom was,
Need not tell of bitterness:
And the brow's more earnest writing
Where it once was marble fair,
May be but the spirit's tracing
Of the peace of answered prayer.

If the smile has gone in deeper,
And the tears more quickly start,
Both together meet in music Low
and tender in the heart;
And in others' joy and gladness,
When the life can find its own,
Surely angels learn to listen
To the sweetness of the tone.

Nothing lost of all we planted
In the time of budding leaves;
Only some things bound in bundles
And set by our precious sheaves;
Only treasure kept in safety,
Out of reach and out of rust,
Till we clasp it grown the richer
Through the glory of our trust.

On the gradual sloping pathway,
As the passing years decline.
Gleams a golden love-light falling
Far from upper heights divine.
And the shadows from that brightness
Wrap them softly in their fold,
Who unto celestial whiteness
Walk, by way of growing old.

22. Old And Young

Christopher Pearse Cranch

They soon grow old who grope for gold
In marts where all is bought and sold;
Who live for self, and on some shelf
In darkened vaults hoard up their pelf
Cankered and crusted o'er with mold.
For them their youth itself is old.

They ne'er grow old who gather gold
Where spring awakes and flowers unfold;
Where suns arise in joyous skies,
And fill the soul within their eyes.
For them the immortal bards have sung;
For them old age itself is young.

23. Age Is Opportunity

[from the longer poem **Morituri Salutamus**]
Henry Wadsworth Longfellow

Is it too late? Ah, nothing's too late
Till the tired heart shall cease to palpitate.
Cato learned Greek at eighty; Sophocles
Wrote his grand "Oedipus," and Simonides
Bore off the prize of verse from his compeers,
When each had numbered more than four-score years;
And Theophrastus at fourscore and ten
Had but begun his "Characters of Men";
Chaucer at Woodstock, with the Nightingales,
At sixty wrote the "Canterbury Tales";
Goethe at Weimar, toiling to the last,
Completed "Faust" when eighty years were past.

What then? Shall we sit idly down and say,
"The night hath come; it is no longer day"?
The night hath not yet come; we are not quite
Cut off from labor by the failing light;
Something remains for us to do or dare.

Even the oldest tree some fruit may bear;
For age is opportunity no less

Than youth itself, though in another dress;
And as the evening twilight fades away,
The sky is filled with stars, invisible by day.

24. Even Such is Time

Sir Walter Raleigh

Even such is Time, that takes in trust
Our youth, our joys, our all we have,
And pays us but with earth and dust;
Who, in the dark and silent grave,
When we have wandered all our ways,
Shuts up the story of our days:
But from this earth, this grave, this dust,
My God shall raise me up, I trust.

["Even Such is Time" by Walter Raleigh was supposedly written the night before his execution. He was beheaded outside Westminster Hall.

His youth was full of joy, he wandered far in expeditions, all was taken away from him, when most of his final years were spent shut up in prison.

The poem is a brief summary of Walter Raleigh's life, concluding with his last great hope,

"My God shall raise me up. I trust."]

25. Father William

Lewis Carroll

'You are old father William,' the young man said,
'And your hair is exceedingly white:
And yet you incessantly stand on your head –
Do you think at your age, it is right?'
'In my youth,' father William replied to his son,
'I feared it might injure the brain:
But now that I'm perfectly sure I have none,
Why I do it again and again.'
'You are old' said the youth, 'as I mentioned before,
And have grown most uncommonly fat:
Yet you turned a back – somersault in at the door
Pray what is the reason for that?'
'In my youth,' said the sage, as he shook his gray locks,
'I kept all my limbs very supple
By the use of this ointment, five shillings the box
Allow me to sell you a couple'

'You are old,' said the youth,
And your jaws are too weak
For anything tougher than suet:

Yet you eat all the goose, with the bones and the beak-
Pray, how did you manage to do it?'

'In my youth' said the old man, 'I took to the law,
And argued each case with my wife,
And the muscular strength, which it gave to my jaw,
Has lasted the rest of my life'

'You are old' said the youth,
'One would hardly suppose that your eye was as steady as
ever:
Yet you balanced an eel at the end of your nose
What made you so clever?'

'I have answered three questions, and that is enough,'
Said his father, 'don't give yourself airs!
Do you think I can listen all day to such stuff?
Be off, or I'll kick you down stairs!'

26. Fat Lie

Anonymous

There's an art to falling apart as the years go by,
And life doesn't begin at forty. That's a big fat lie.

. . . .

I'm aware I walk a little slower
The slightest move seems to take forever,
My knees have become kind of wobbly
Matters not when or where
My bladder keeps wanting to pee
Hee .. hee – Sorry

27. King Lear (Act 4, Scene 7)

William Shakespeare

Lear: Pray, do not mock:
I am a very foolish fond old man,
Fourscore and upward, not an hour more or less;
And to deal plainly,
I fear I am not in my perfect mind.
Methinks I should know you and know this man,
Yet I am doubtful, for I am mainly ignorant
What place this is, and all the skill I have
Remembers not these garments; nor I know not
Where I did lodge last night. Do not laugh at me,
For, as I am a man, I think this lady
To be my child Cordelia.

Cordelia, weeping And so I am, I am.

[King Lear is a play about blindness – blindness to the importance of selfless love. Once he loses his power Lear gains insight into his own nature and realizes his shortcomings admitting, "mine eyes are not of the best."

He finally sees life as it really is, but is powerless to do anything about it.]

28. All the World's a Stage from

As You Like (Act 2, Scene 7)

William Shakespeare

[The monologue "All the World's a Stage" is a realistic poem by who else than Shakespeare. The main theme of this poem is that man is the ultimate loser in the game of life.

In the very beginning, the poet has compared the whole world with a stage where men and women are merely players. They have their entrances and exits. They enter the world (stage) when they are born and exit when they die. Here in this stage, every man has to play seven different roles based on his age during his lifetime.

Infanthood Stage 1.

The first stage of a man's life is infanthood. He plays in the arms of his nurse (mother). He very often vomits and cries in this stage. He is fully dependent on other's care.

Stage of Boyhood. 2.

In his second stage of boyhood, he is a school-going student. He slings his school bag over his shoulder with his shining face and creeps to school unwilling like a snail.

Stage of a Lover. 3.

He becomes a lover. Here his breath is hot. He is very busy composing ballads for his beloved's eye brows and yearns for her attention.

Stage of a soldier. 4.

In the fourth stage, he is aggressive and ambitious, full of strange oaths. He seems like a leopard with his beard. He seeks reputation in all that he does. He is willing to die in a battle to earn, "the bubble of reputation." He is ready to guard his country and become a soldier.

Stage of maturity and wisdom. 5.

In his fifth stage, he becomes a fair judge with maturity and wisdom. He has a potent belly. He seems firm and serious with his eye and formal cut beard. He tries to provide justice to others.

Stage of Old Age. 6.

In his sixth stage, he is seen with loose pantaloons and spectacles. He becomes a thin man. His manly voice changes into thin childish tones.

Stage of Extreme Old Age (Second Childhood). 7.

The last stage of all is his second childhood. Slowly, he loses his sight, hearing, smell and taste and exits from the roles of his life.

Thus, Shakespeare has presented different images of the seven stages of a man's life in the poem, "All the World's a Stage."

Life is like a drama, and the world's a stage where we are actors and play our roles.]

"All the world's a stage,
And all the men and women merely players;
They have their exits and entrances,
And one man in his time plays many parts,
His acts being seven ages. At first the infant,
Mewling and puking in the nurse's arms;
And then the whining schoolboy, with his satchel
and shining morning face, creeping like snail
Unwillingly to school. And then the lover.

Sighing like a furnace, with a woeful ballad
Made to his mistress' eyebrow.
Then a soldier full of strange oaths, and bearded like the
pard,
Jealous in honor, sudden and quick in quarrel,
Seeking the bubble reputation
Even in the cannon's mouth.
And then the justice in fair round belly with good capon
lined,
With eyes severe and beard of formal cut,
Full of wise saws and modern instances;
And so he plays his part.
The sixth stage shifts into the lean and slippered pantaloon,
With spectacles on nose and pouch on side;
His youthful hose, well saved, a world too wide
For his shrunk shrank; and his big manly voice,
Turning again toward childish treble, pipes
And whistles in his sound.
Last scene of all that ends this strange eventful history,
Is second childishness and mere oblivion,
Sans teeth, sans eyes, sans taste, sans everything."

29. I look into my glass

Thomas Hardy

I look into my glass
And view my wasting skin,
And say "Would God it came to pass
My heart had shrunk as thin!"

. . . .

But Time, to make me grieve,
Part steals, lets part abide;
And shakes this fragile frame at eve
With throbbing of noontide.

[This short poem shares a simple message. The speaker looks at himself in his mirror and sees his wrinkled and aging skin. He wishes that his heart was similarly weakened and reduced. The poem implies that the speaker leans to the thoughts of being a young man who is still capable of feeling love, romantic longing and infatuation.]

30. Death, be not proud

John Donne

Death, be not proud, though some have called thee
Mighty and dreadful, for thou art not so;
For those whom thou think'st thou dost overthrow
Die not, poor Death, nor yet canst thou kill me.
From rest and sleep, which but thy pictures be,
Much pleasure; then from thee much more must flow,
And soonest our best men with thee do go,
Rest of their bones, and soul's delivery.
Thou art slave to fate, chance, kings, and desperate men,
And dost with poison, war, and sickness dwell,
And poppy or charms can make us sleep as well
And better than thy stroke; why swell'st thou then?
One short sleep past, we wake eternally
And death shall be no more; Death, thou shalt die.

31. On Himself

Robert Herrick

A wearied pilgrim I have wandered here,
Twice five-and-twenty, bate me but one year;
Long I have lasted in this world; 'tis true
But yet those years that I have lived, but few.
Who by his gray hairs doth his lustres tell,
Lives not those years, but he that lives them well:
One man has reached his sixty years, but he
Of all those three-score has not lived half three:
He lives who lives to virtue; men who cast
Their ends for pleasure, do not live, but last.

32. Sound, Sound the Clarion

Sir Walter Scott

Sound, sound the clarion, fill the fife!
To all the sensual world proclaim,
One crowded hour of glorious life is
worth an age without a name.

33. The Old Man's Complaints. And how he gained them

Robert Southey

You are old, Father William, the young man cried,
The few locks which are left you are grey;
You are hale, Father William, a hearty old man,
Now tell me the reason I pray.

In the days of my youth, Father William replied,
 I remembered that youth would fly fast,
And abused not my health and my vigor at first
That I never might need them at last.

You are old, Father William, the young man cried,
 And pleasures with youth pass away,
And yet you lament not the days that are gone,
Now tell me the reason I pray.

In the days of my youth, Father William replied,
 I remembered that youth could not last;
I thought of the future whatever I did,
 That I never might grieve for the past.

You are old, Father William, the young man cried,
 And life must be hastening away;
You are cheerful, and love to converse upon death!
 Now tell me the reason I pray.

I am cheerful, young man, Father William replied,
Let the cause thy attention engage;
In the days of my youth I remembered my God!

And He hath not forgotten my age.

34. Written in a Carefree Mood

Lu Yu

Old man pushing seventy
In truth he acts like a little boy
Whooping with delight when he spies some mountain fruits,
Laughing with joy, tagging after village mummers;
With the others having fun stacking tiles to make a pagoda,
Standing alone staring at his image in a jardiniere pool.
Tucked under his arm, a battered book to read,
Just like the time he first set off for school.

35. Parody based on "My Favorite Things" from "Sound of Music"

[Supposedly, on her 79th birthday Julie Andrews sang "My Favorite Things" from the "Sound of Music" with different words, very appropriate for those getting older. The story is a hoax; however, whoever wrote these new words to go with the music (the writer has never been identified) shows great wit and real insight into aging.]

Botox and nose drops and needles for knitting,
Walkers and handrails and new dental fittings,
bundles of magazines tied up in string, These
are a few of my favorite things.

. . . .

When the joints ache, when the hips break,
When the eyes grow dim,
Then I remember the great life I've had,
And then I don't feel so bad.

Some Parting Thoughts

It's an odd pronouncement to want to be a writer at this stage of my life. It's not like I have decades left to develop a craft or career. I doubt that I'll ever become famous or rich doing it.

Yet I must read and then write. Just as a mosquito must bite.

Is it really too late?

Toni Morrison and Tom Wolfe were prolific writers well past four score years. Cato learned Greek at eighty. Sophocles wrote his grand "Oedipus" past years four score and ten.

The question we who have traveled beyond the eighty-mark mile post should ask is, "What now?" It's for us to resolve this question because for us the night hath yet to come. Something surely remains for us to do or dare.

Nothing is too late till the tired heart ceases to palpitate.

What then? Shall we sit idly down and say, "The night has come; it is no longer day?" The night I say hath not yet come; we are not quite cut off from labor by the

failing light. Something remains for us to do or dare. Even the oldest tree some fruit may bear. Let's not forget, as the evening twilight fades away, the sky is filled with stars invisible by day. Remember fishermen navigate by the light of the moon. The darkest hour is before dawn.

The National Geographic and the AARP did a study on the second half of life. The results are refreshing. Their conclusion was that most of the prevalent opinions and stereotypes about aging are incorrect.

The overall message was "refreshingly positive and reassuring." "On the whole, life is good, especially for those over 60. And the person you see in the mirror is far different from the type of person younger generations might think you are. The survey posed this tantalizing proposition. Would you take a pill that immediately granted 10 bonus years of life? While around three quarters of adults across all age ranges said they likely would take such a pill, one interesting finding was that those 80 and older were the least interested. And when the question was posed without an age guarantee, but instead cited the promise of slower aging with extended health, the likelihood of taking such a pill shot up to around 85 percent."

My wish for each of us is that we might all settle into aging with a feeling of release and completion and fulfillment.

The last stanza from "Three Best Things" by Henry Van Dyke is a fitting conclusion:

"So let the way wind up the hill or down,
O'er rough or smooth, the journey will be joy.
Still seeking what I sought when but a boy,

New friendship, high adventure and a crown,
My heart will keep the courage of the quest,
And hope the road's last turn will be the best."

I end this book with humility, well aware that I'm not qualified to write it. What I am is one lucky man when it comes to family, friends, and colleagues. Over the past almost nine decades I could not have found better companions for the journey.

But of this I am certain: that I've come this far makes me one lucky guy. THIS I OWE ENTIRELY TO MY FAMILY AND FRIENDS – YES ENTIRELY.

I thank almighty God for the two hands always by my side, for the two feet for supporting me and for the fingers I can count on.

Said Joe Louis, the Brown Bomber, "I did the best I could with what I had." So did I.

Printed in the United States
by Baker & Taylor Publisher Services